This Book Belongs To:

THE BENEFITS OF COLORING THERAPY

Coloring really is a therapy. It is a fantastic and effective medium for relieving stress and restoring calm in a busy, chaotic & stressful world like ours.

Coloring therapy helps a person to express and release their energy by transferring their thoughts and feelings onto paper. By using full concentration and focus, it helps to bring about feelings of calm and respite allowing a person to forget about what is going on in their busy world for even a few minutes a day. It brings clarity of thought and helps us to refocus on the positive when we return back to the world. The medium of Color is powerful to release energy's with each color resonating to a different feeling. It is a very therapeutic exercise almost like a waking meditation.

I have been using it therapeutically for years and can attest to it's benefits.

So keep this book close and pick it up often, particularly if you are feeling overwhelmed or frazzled with what is going on in your life. Try to lose yourself in the picture and activity and your brain will soon resonate to a different and more calming vibration.

Most of all – enjoy!!!! You *will feel* the benefits ☺

COLOR TEST PAGE

Pick a color to match an emotion or simply use this page to test your color's before you to use them

COLOR TEST PAGE

Pick a color to match an emotion or simply use this page to test your color's before you to use them

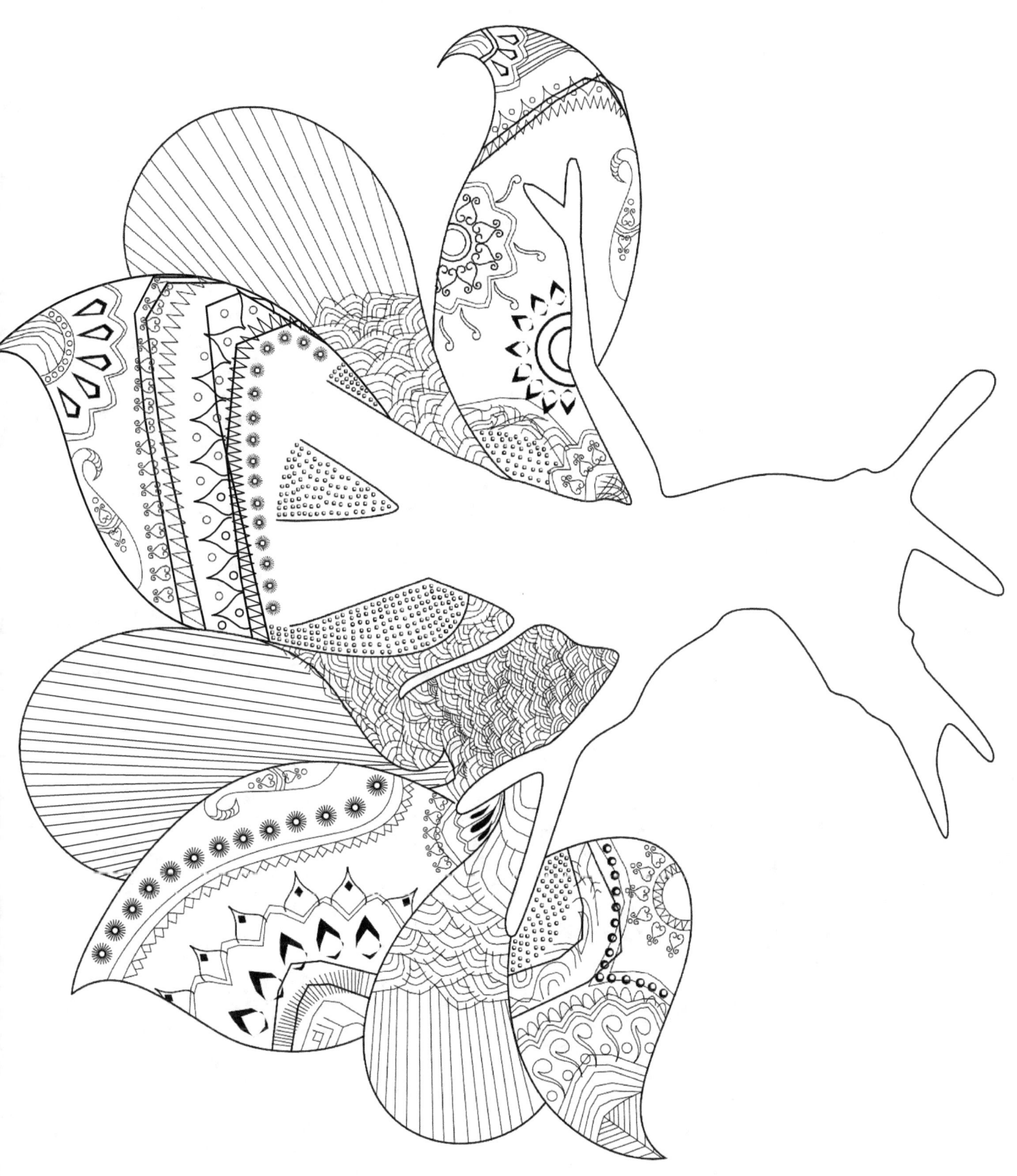

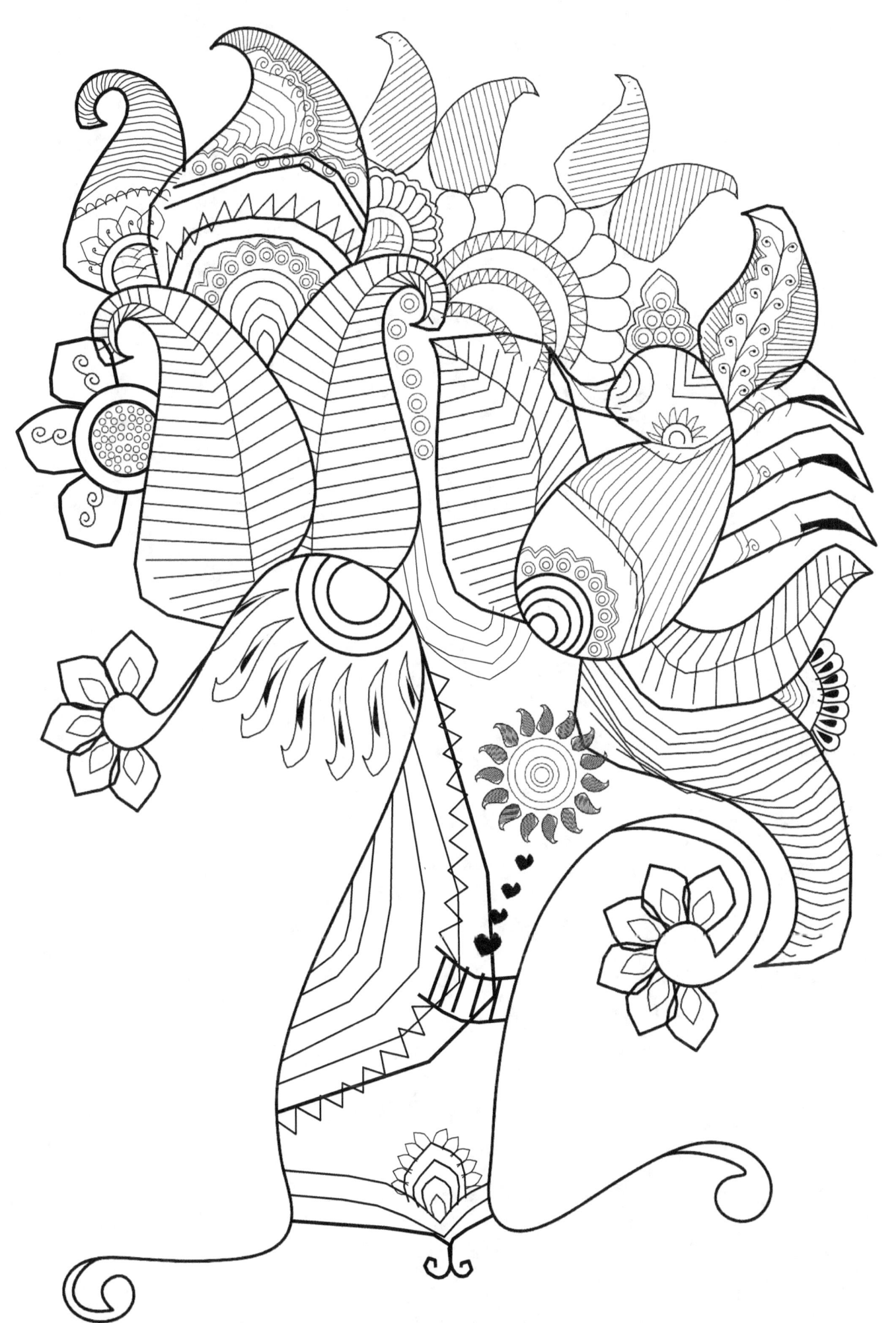

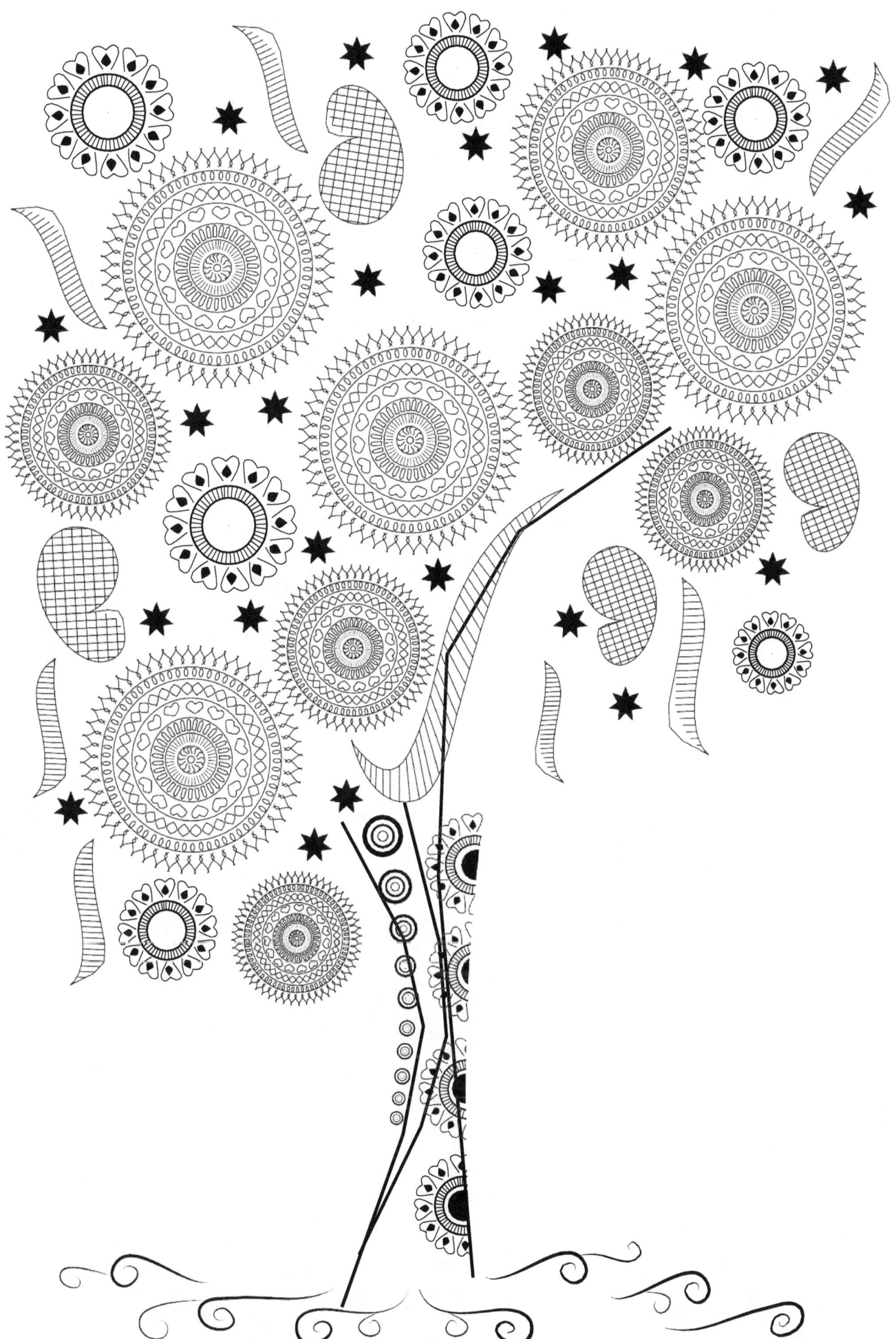

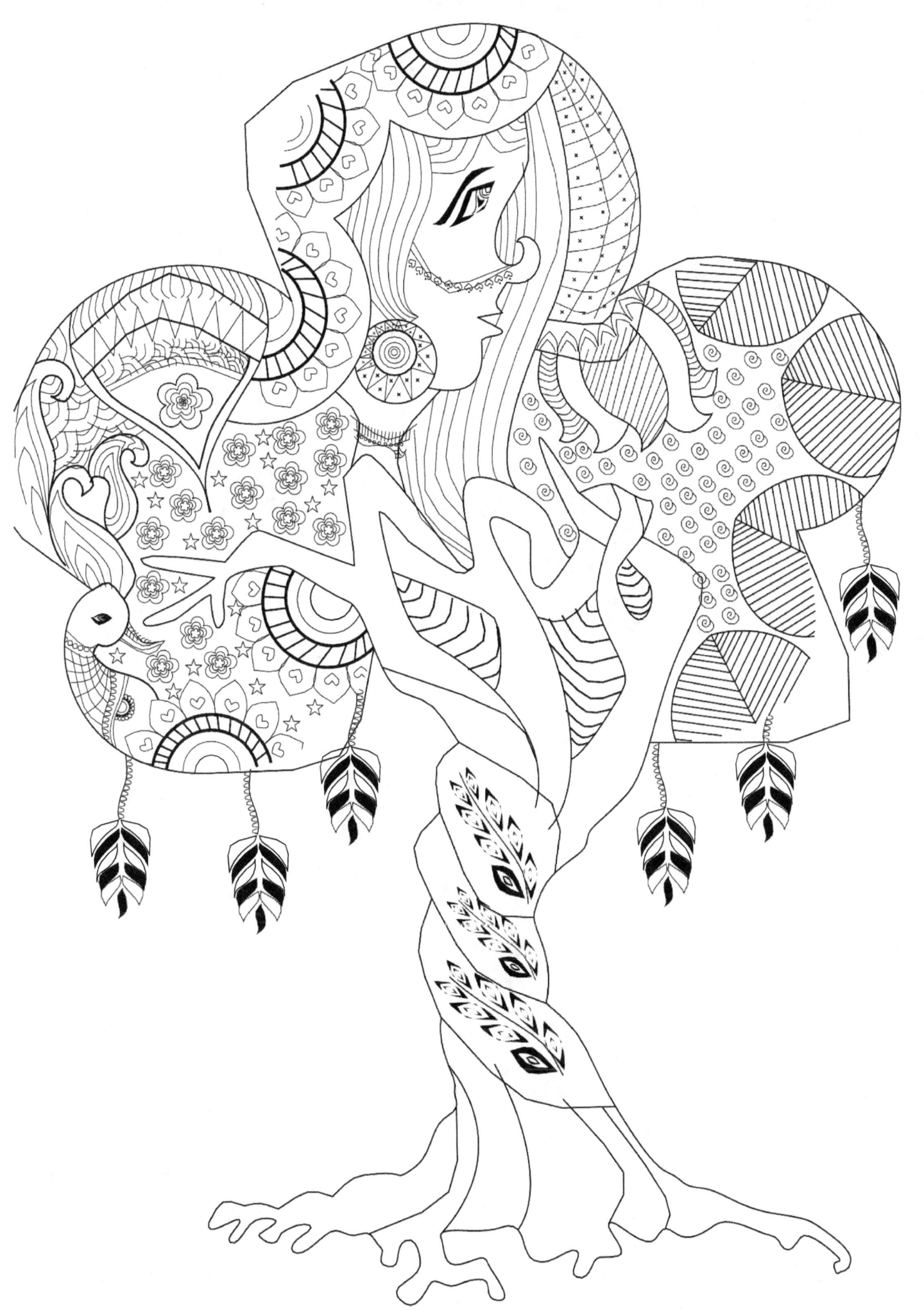

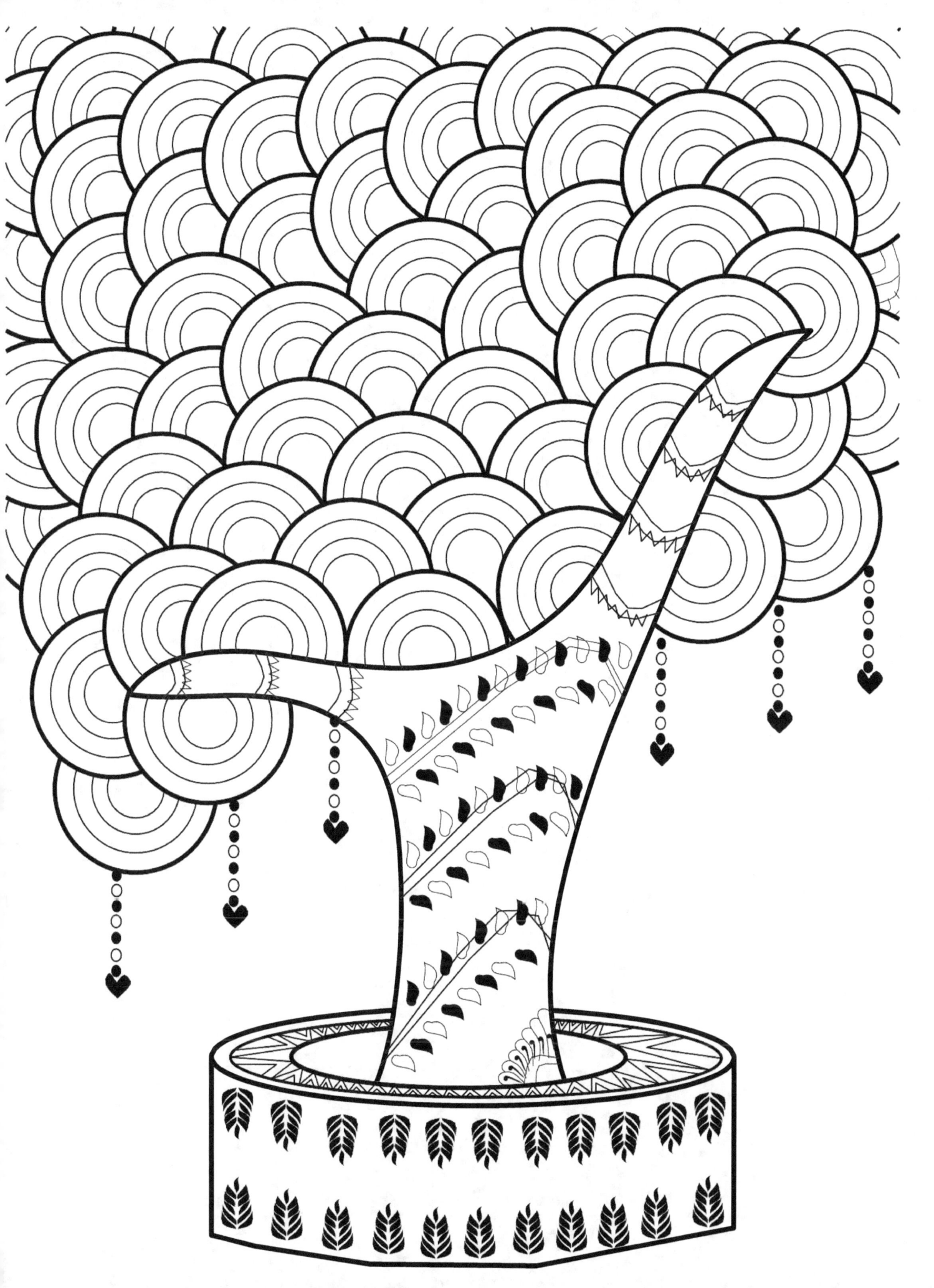

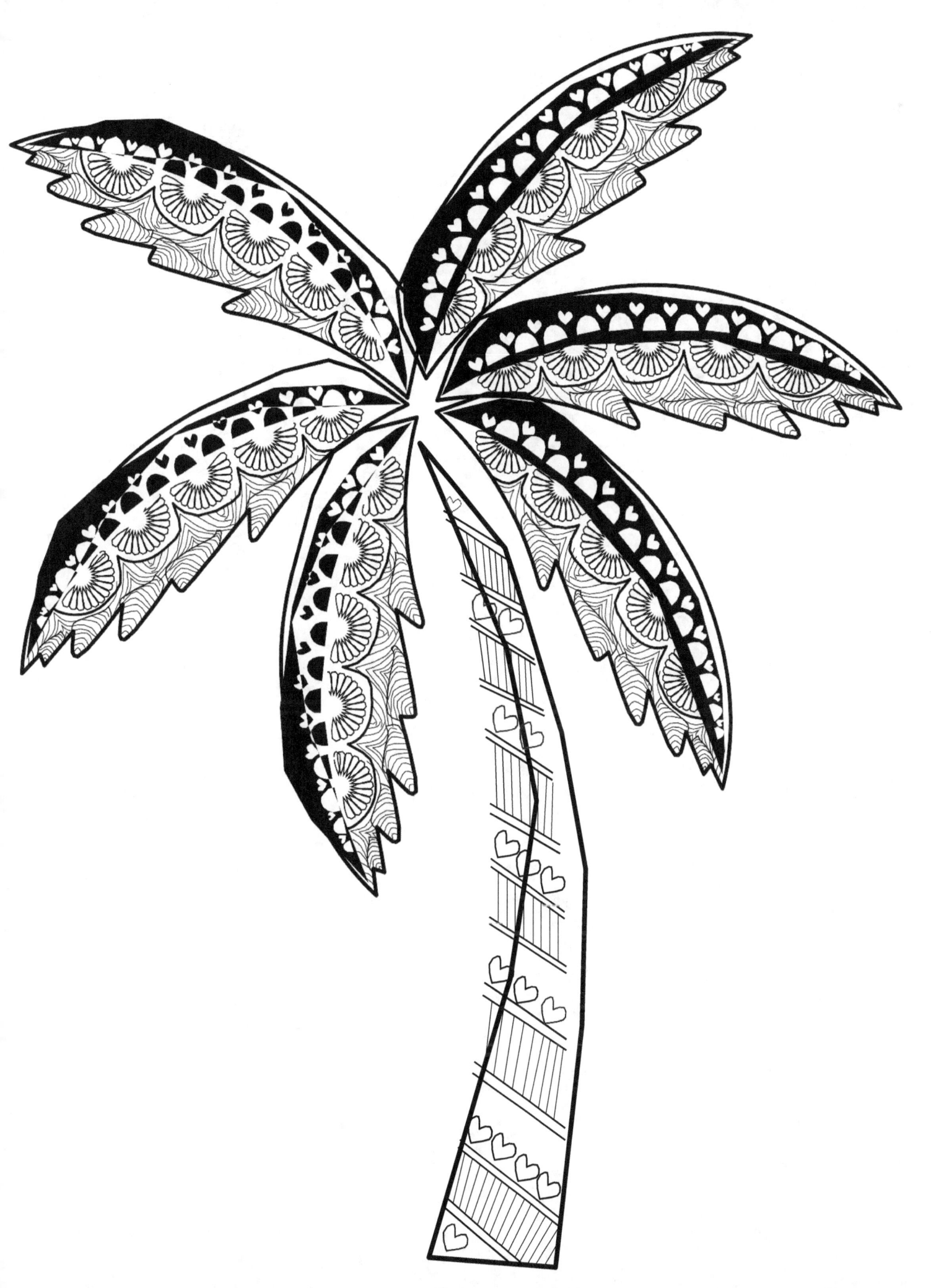

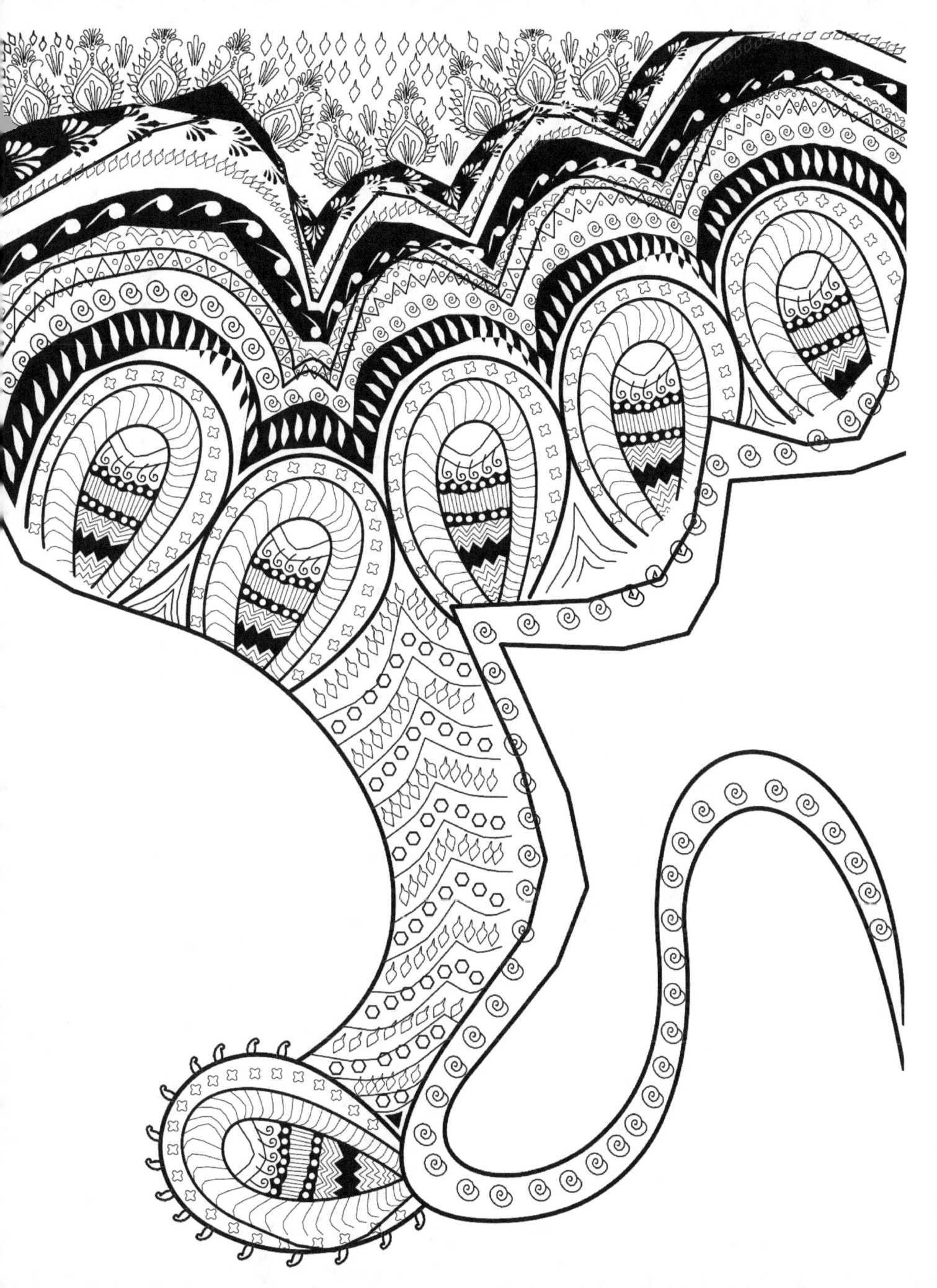

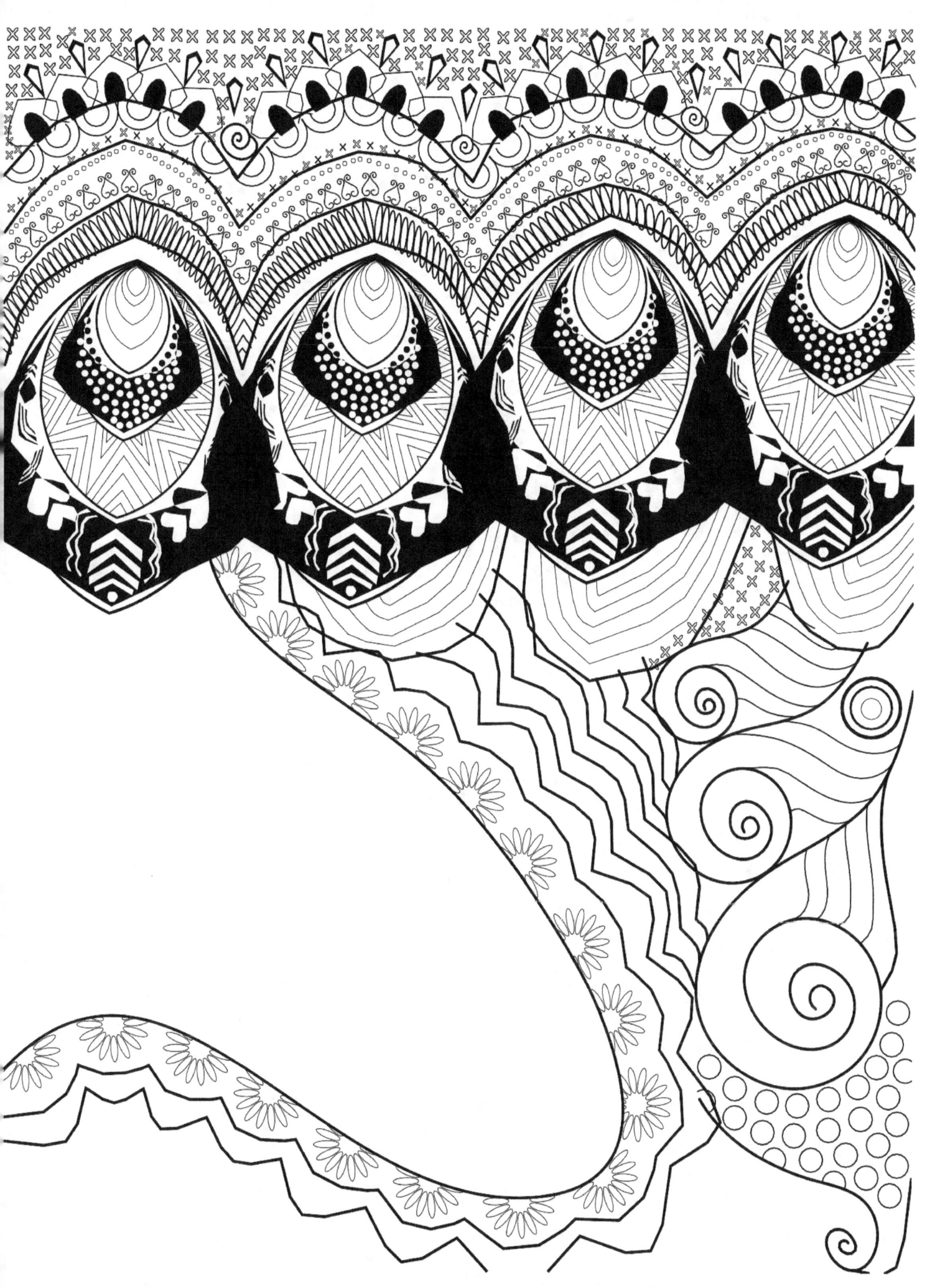

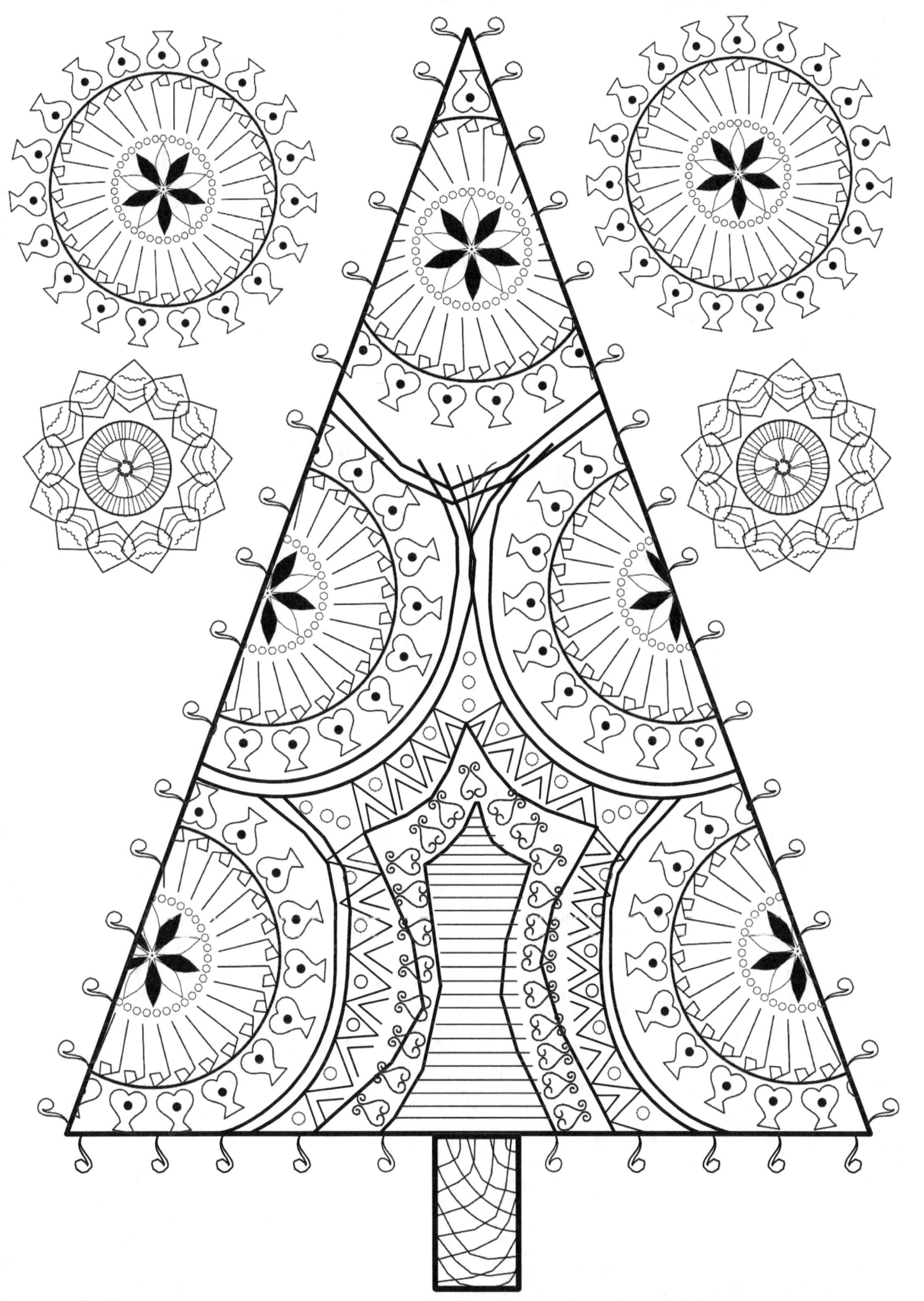

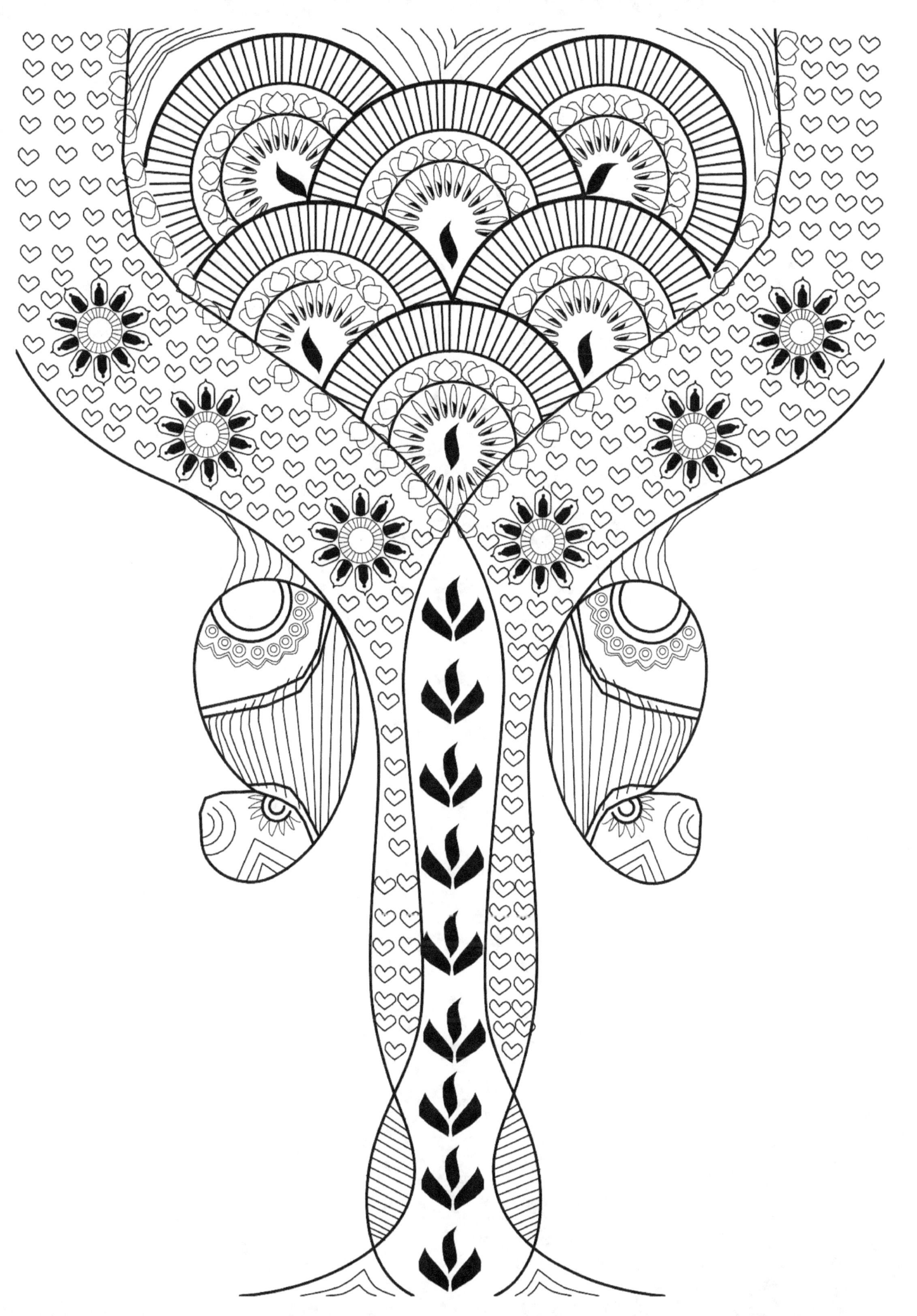

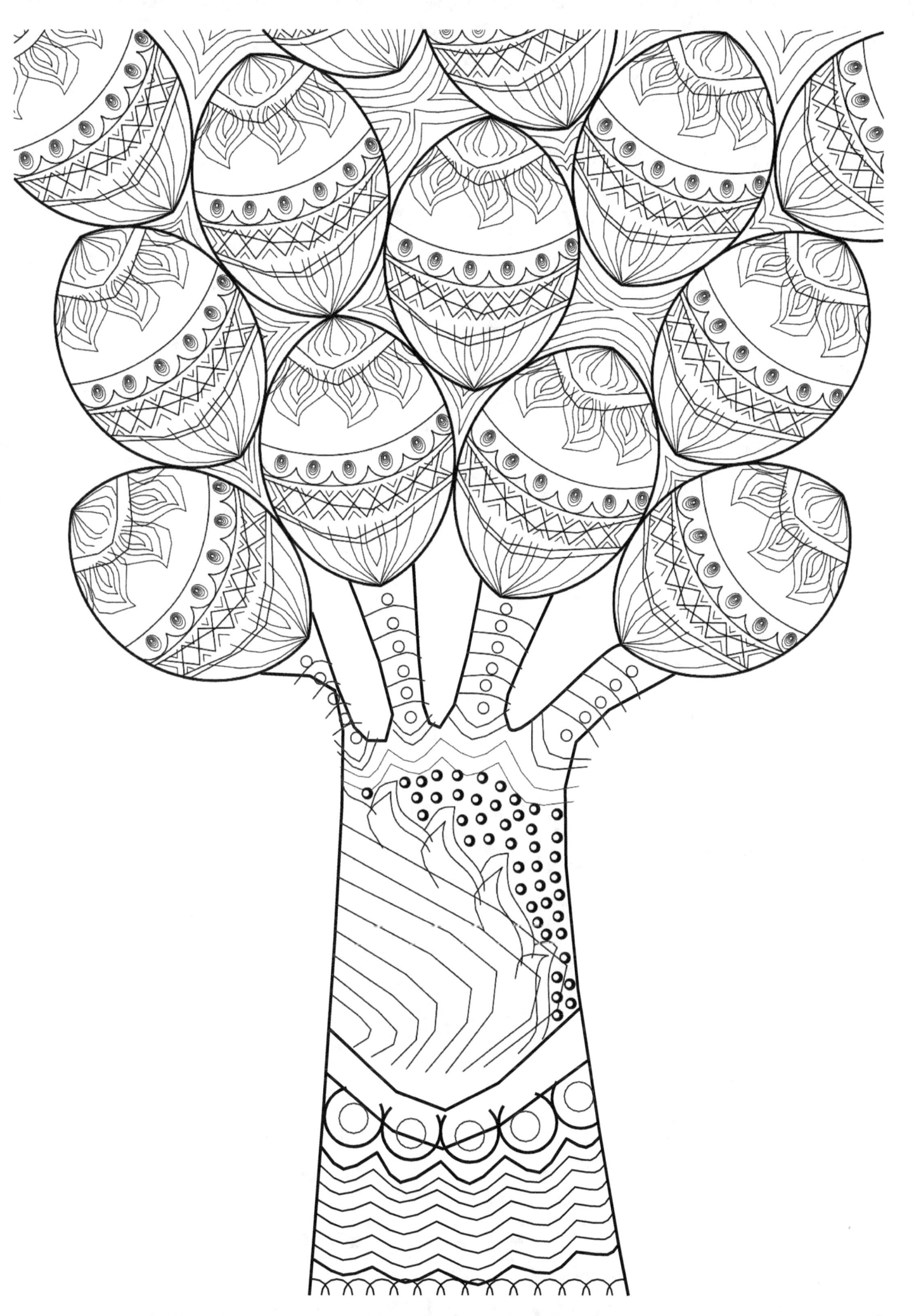

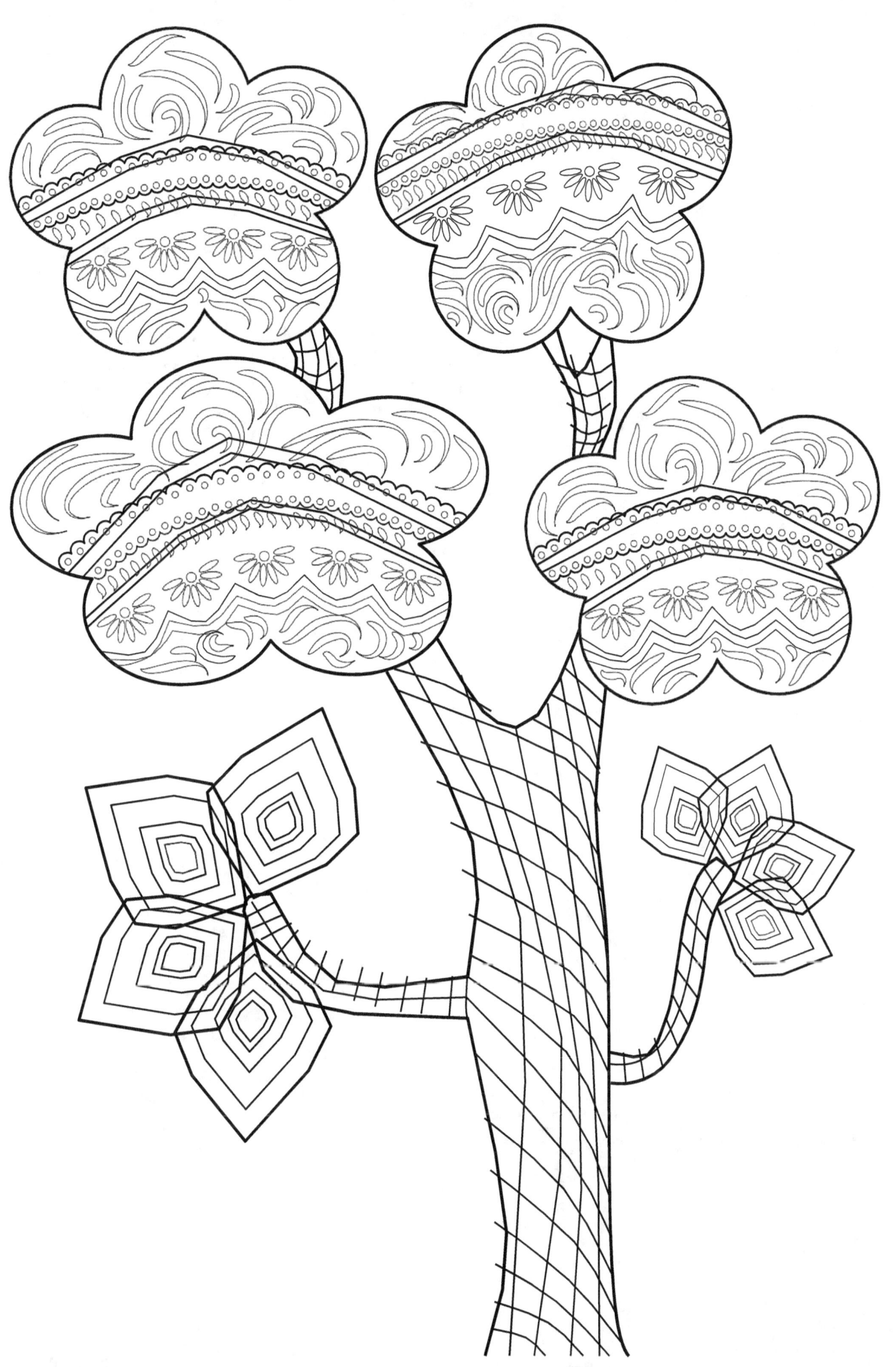

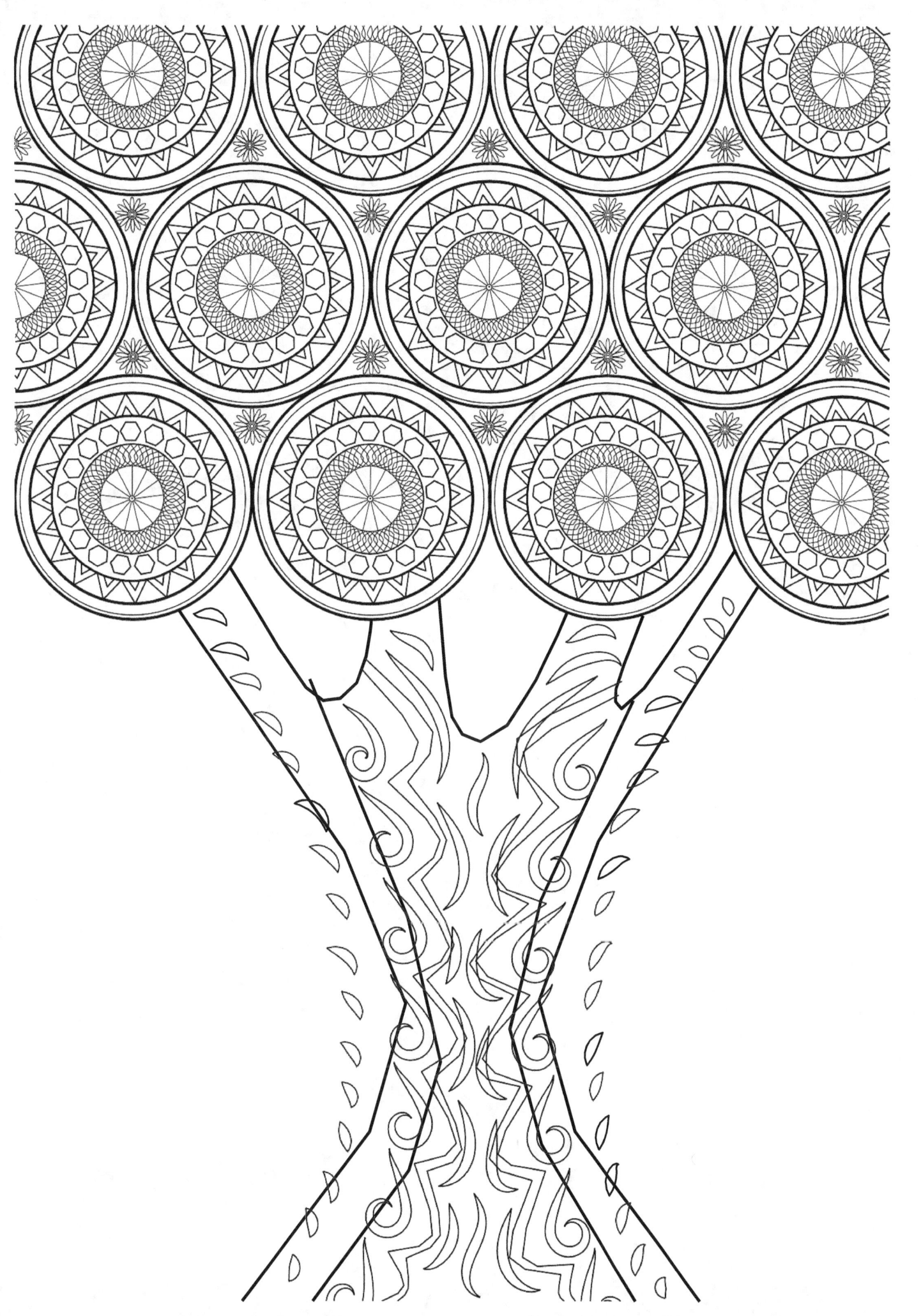

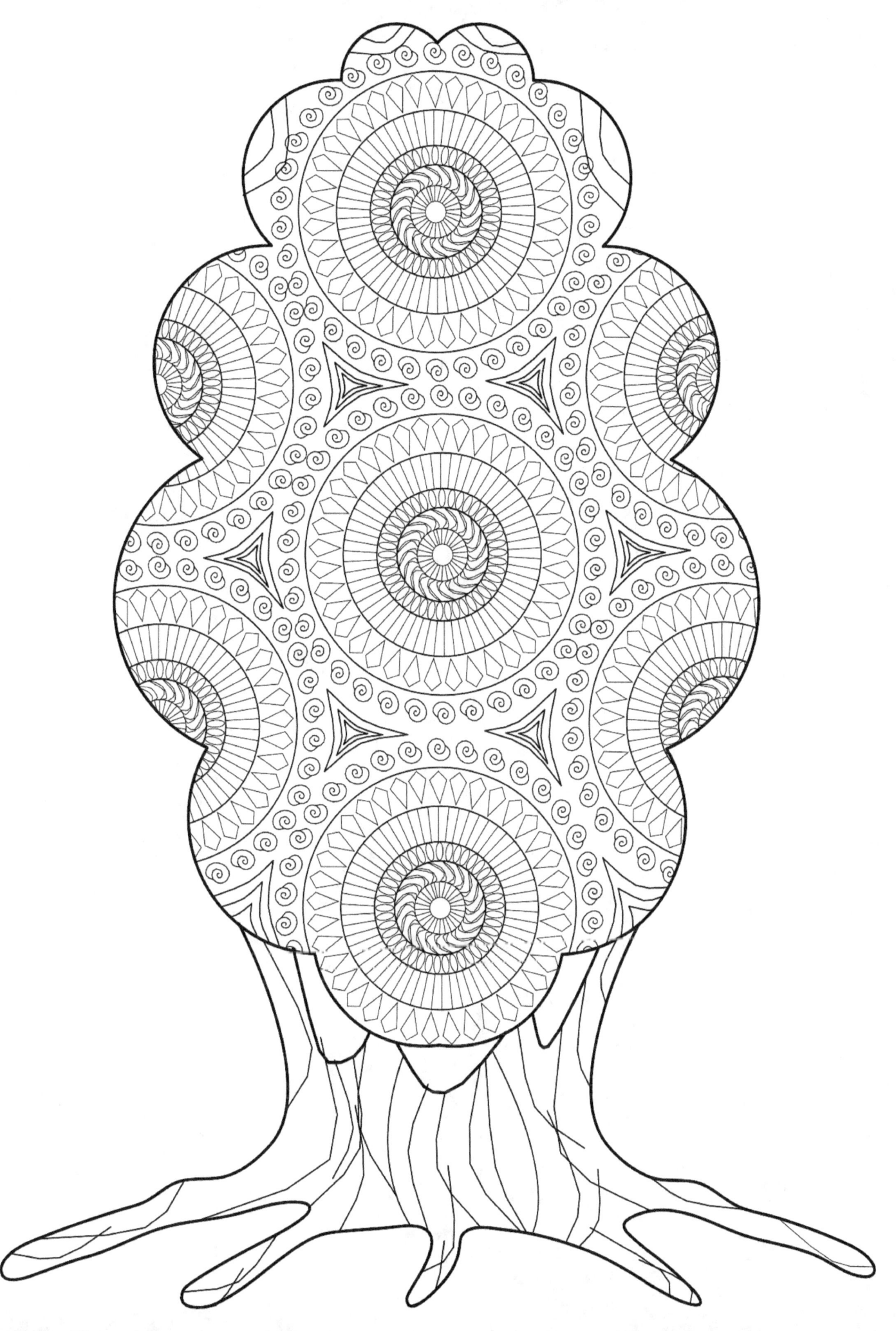

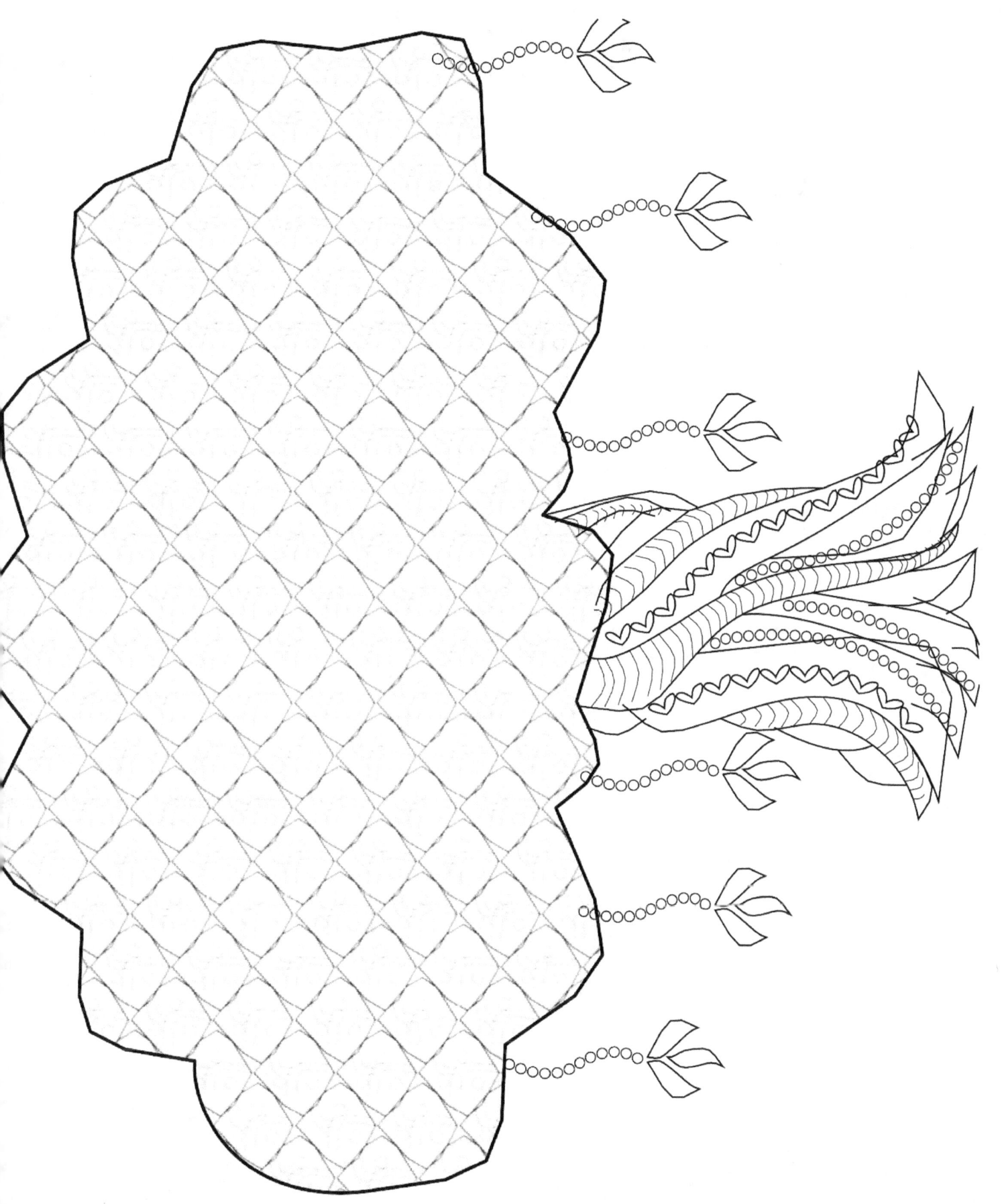

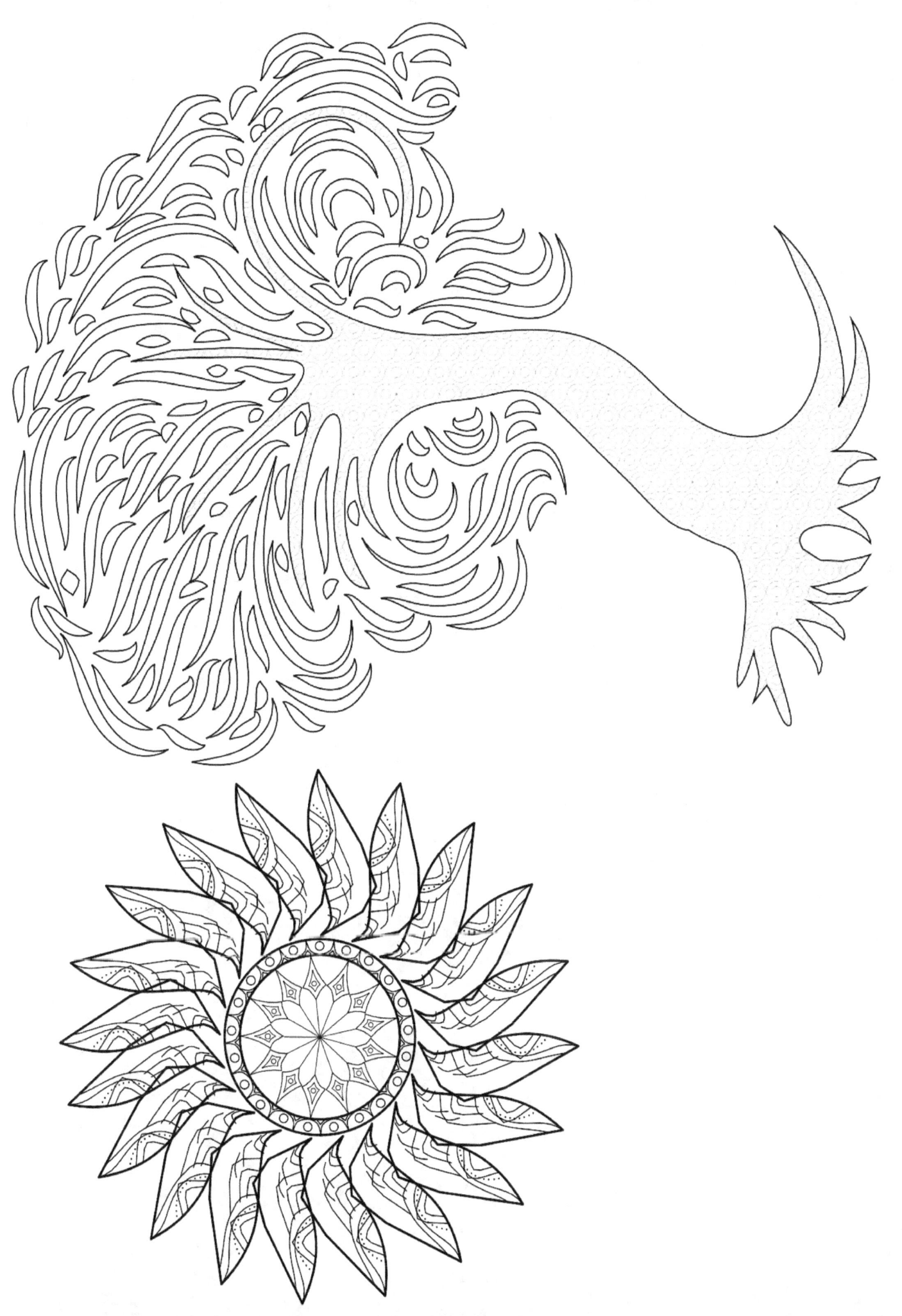

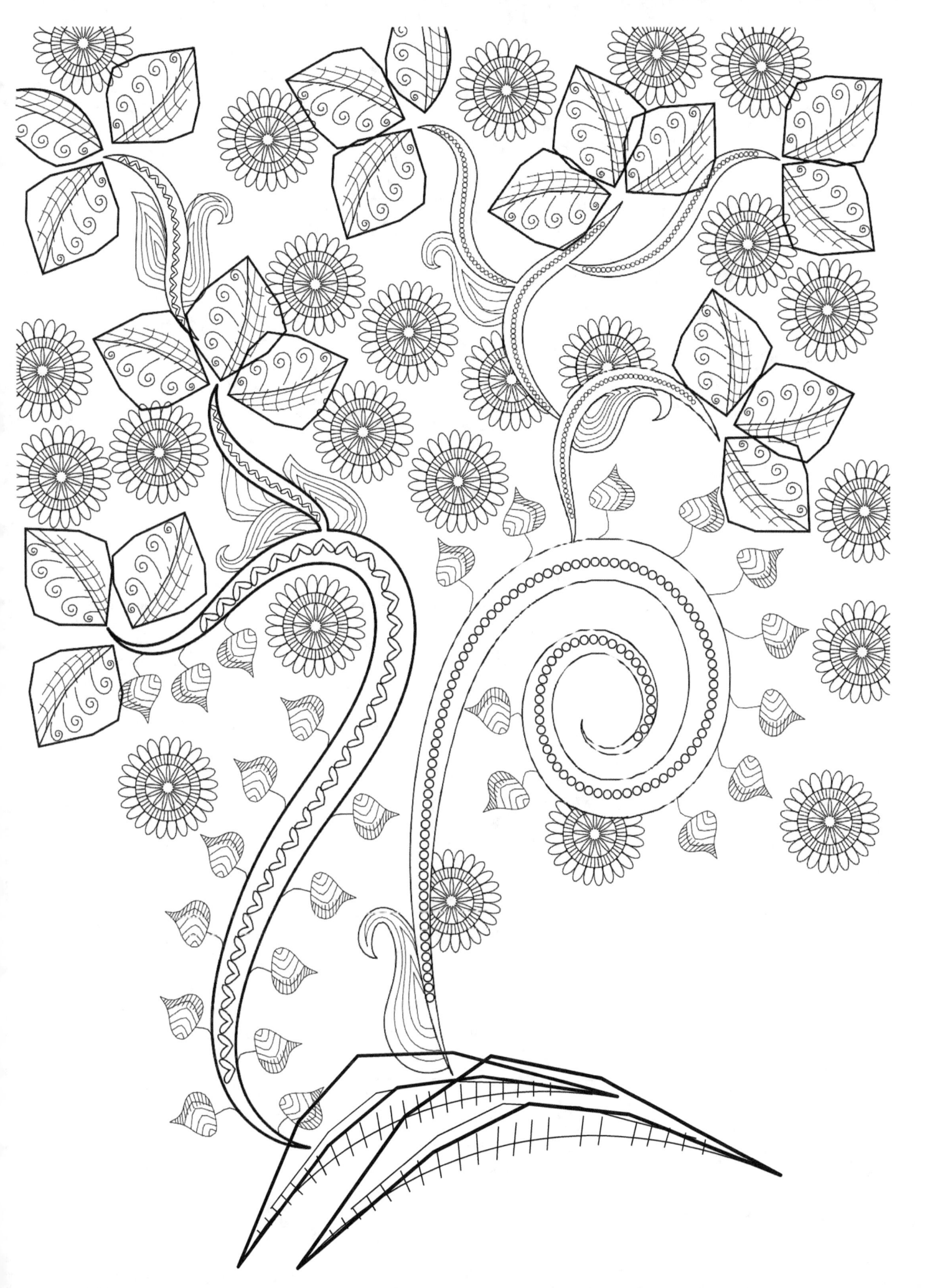

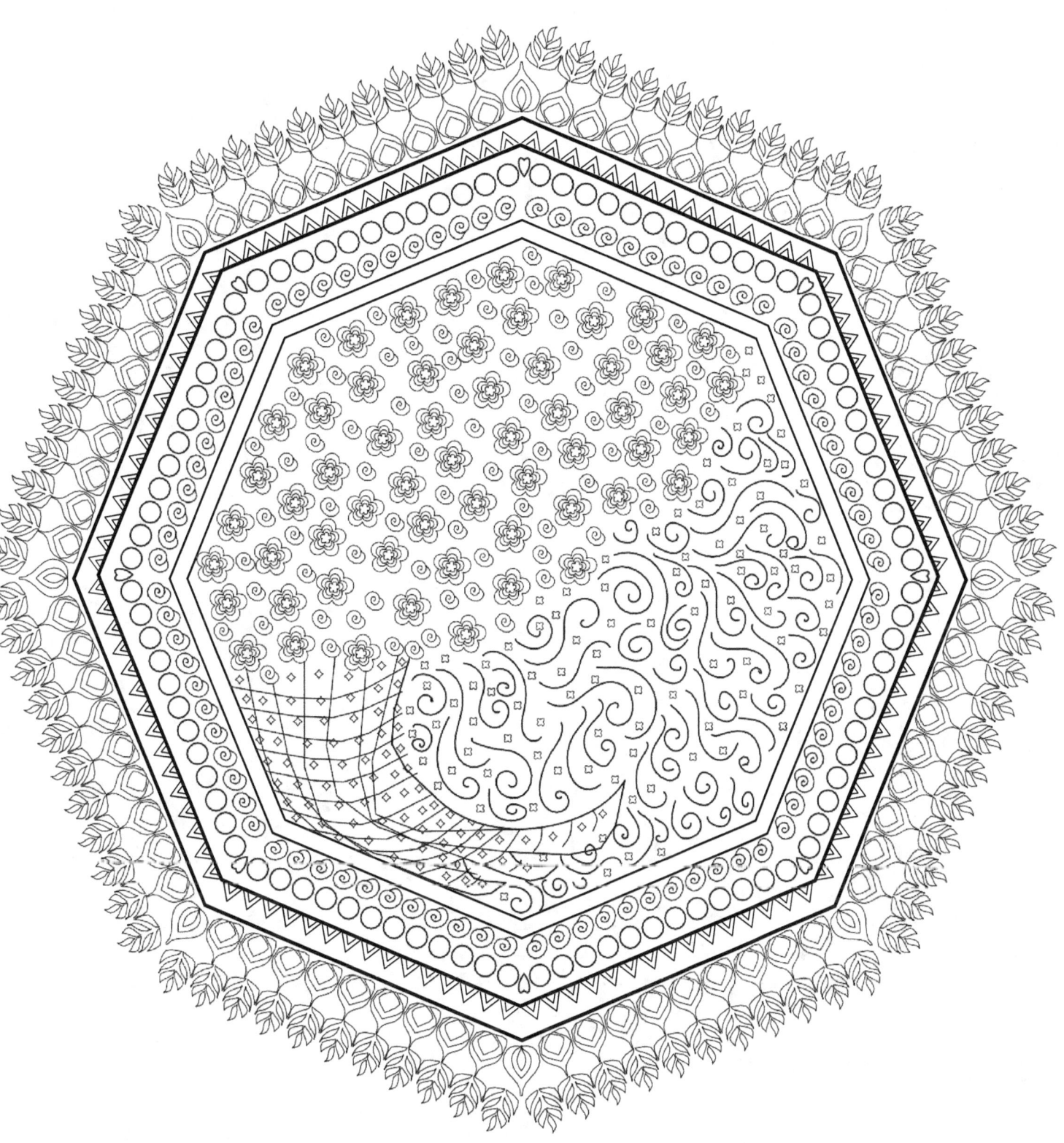

www.ingramcontent.com/pod-product-compliance
Lightning Source LLC
Chambersburg PA
CBHW081654220526
45466CB00009B/2751